Fernando Botero

フェルナンド・ボテロ

TASCHEN

KÖLN LONDON LOS ANGELES MADRID PARIS TOKYO

In June 1951 an enterprising photographer displayed 25 works in his studio in Bogotá (Colombia) including watercolors, drawings and oil paintings by a young, unknown artist, who had only recently arrived in the capital from the provinces. His success on this occasion was modest, but not discouraging. Not quite one year later, Leo Matiz – for that was the photographer's name – held another exhibition of the same artist's work. This time with resounding success, for all the works were sold. Not one of those involved at the time could have had any idea that the 19-year-old Fernando Botero from Medellín would one day be Latin America's most famous painter. Botero has had over 50 solo exhibitions in museums throughout the world, from Tokyo to Washington, from Stockholm to Caracas. No painter in recent decades has exerted such a wide influence. Botero's work now comprises almost 3,000 paintings in addition to more than 200 sculptures and countless drawings and watercolors. It is a vast œuvre, which without a doubt stands up to critical examination.

FERNANDO BOTERO
Photo: Francesco Zizola

Ein umtriebiger Fotograf zeigte im Juni 1951 in seinen Atelierräumen in Bogotá (Kolumbien) 25 Werke, darunter Aquarelle, Zeichnungen und Ölgemälde eines jungen, unbekannten Künstlers, der erst vor kurzem aus der Provinz in die Hauptstadt gezogen war – mit bescheidenem, doch nicht entmutigendem Erfolg. Knapp ein Jahr später stellte Leo Matiz – so hieß dieser Fotograf – den gleichen Künstler noch einmal aus. Diesmal mit großem Erfolg, denn es wurden alle Werke verkauft. Keiner konnte ahnen, dass der 19-jährige Fernando Botero aus Medellín eines Tages einer der berühmtesten Maler Lateinamerikas sein würde. Botero ist in über 50 Einzelausstellungen von Museen aus aller Welt, von Tokio über Stockholm und Washington bis Caracas ausgestellt worden. Kein Maler hat in den letzten Jahrzehnten solch eine weltweite Breitenwirkung erlebt. Boteros Werk umfasst inzwischen fast 3.000 Gemälde, über 200 Skulpturen und unzählige Zeichnungen und Aquarelle. Es ist ein gewaltiges Werk, das der Prüfung zweifellos standhält.

Juin 1951 – un photographe très affairé de Bogotá (Colombie) expose dans son atelier 25 aquarelles, dessins et toiles à l'huile d'un jeune artiste inconnu, à peine arrivé de sa province. L'accueil est, certes, très réservé, mais nullement décourageant. Presque un an plus tard, Leo Matiz – c'est le nom du photographe – présente à nouveau des œuvres de l'artiste. Cette fois, le succès est au rendez-vous, puisque toutes les toiles sont vendues. Nul ne peut alors imaginer que Fernando Botero, ce jeune artiste de Medellín âgé de 19 ans seulement, va devenir l'un des plus illustres artistes d'Amérique du Sud. Botero a été présenté dans les plus grands musées du monde, de Tokyo à Caracas, de Stockholm à Washington, avec plus de 50 expositions personnelles. Botero a réalisé à ce jour près de 3000 tableaux, plus de 200 sculptures ainsi que d'innombrables dessins et aquarelles. C'est une œuvre considérable, à même de résister à tout examen sérieux.

En junio de 1951, un fotógrafo inquieto presentó en las salas de su estudio de Bogotá (Colombia) una pequeña exposición de 25 obras, entre las que se encontraban acuarelas, dibujos y óleos de un artista joven y desconocido que poco antes se había trasladado a la capital. La exposición cosechó un éxito modesto, pero no desalentador. No había pasado un año cuando Leo Matiz –así se llamaba dicho fotógrafo– volvió a exponer al mismo artista; ahora, el éxito fue grande, pues se vendieron todas las obras. Ninguno de los que participaron entonces en la exposición –Fernando Botero de Medellín, entonces de 19 años de edad– podían imaginarse que llegaría a convertirse un día en uno de los pintores más famosos de América Latina. Botero ha presentado más de 50 exposiciones individuales museos de todo el mundo, desde Tokio a Caracas, desde Estocolmo a Washington. Ningún otro pintor ha tenido tan amplia repercusión mundial en los últimos años. La obra de Botero comprende ya casi 3.000 óleos, más de 200 esculturas e innumerables dibujos y acuarelas. Es una obra inmensa, que resiste la crítica.

1951年6月、ある仕事熱心な写真家がコロンビアの首都ボゴタの自分のスタジオで、水彩画、ドローイング、油彩画25点を集めて展覧会を開いた。これらの作品は地方からボゴタに出てきたばかりのある若い無名アーティストのもので、この展覧会はささやかながら、気持ちに張りを与える成功を収めた。その約1年後、レオ・マティス——これが写真家の名前である——は同じアーティストの作品を再び展示した。今回の成功は大きかった。作品は完売したのである。メデジン出身の19歳のアーティスト、フェルナンド・ボテロがいずれラテンアメリカで最も著名な画家になろうとは、当時誰も想像することはできなかった。ボテロの作品は、東京から、ストックホルム、ワシントン、そしてカラカスに至る、世界中の美術館で開催された50以上の個展で展示されてきた。過去数十年間に、これほど世界に幅広く影響を及ぼした画家はほかにいない。ボテロの作品の数は今では、絵画が約3000点、彫刻が200点以上、そしてドローイングと水彩画は数え切れないほどになっている。それらがいかなる批判的なまなざしにも耐え得る圧倒的な仕事であることは疑う余地がない。

© 2006 TASCHEN GmbH
Hohenzollernring 53, D-50672 Köln
www.taschen.com
© 2006 Fernando Botero for all illustrations
Cover: The Death of Luis Chaleta, 1984
Japanese translation: Yoko Suzuki, Cologne

To stay informed about upcoming TASCHEN titles,
please request our magazine at www.taschen.com/magazine
or write to TASCHEN, Hohenzollernring 53, D-50672 Cologne,
Germany, contact@taschen.com, Fax: +49-221-254919.
We will be happy to send you a free copy of our magazine
which is filled with information about all of our books.

Printed in China
ISBN 3-8228-5073-X

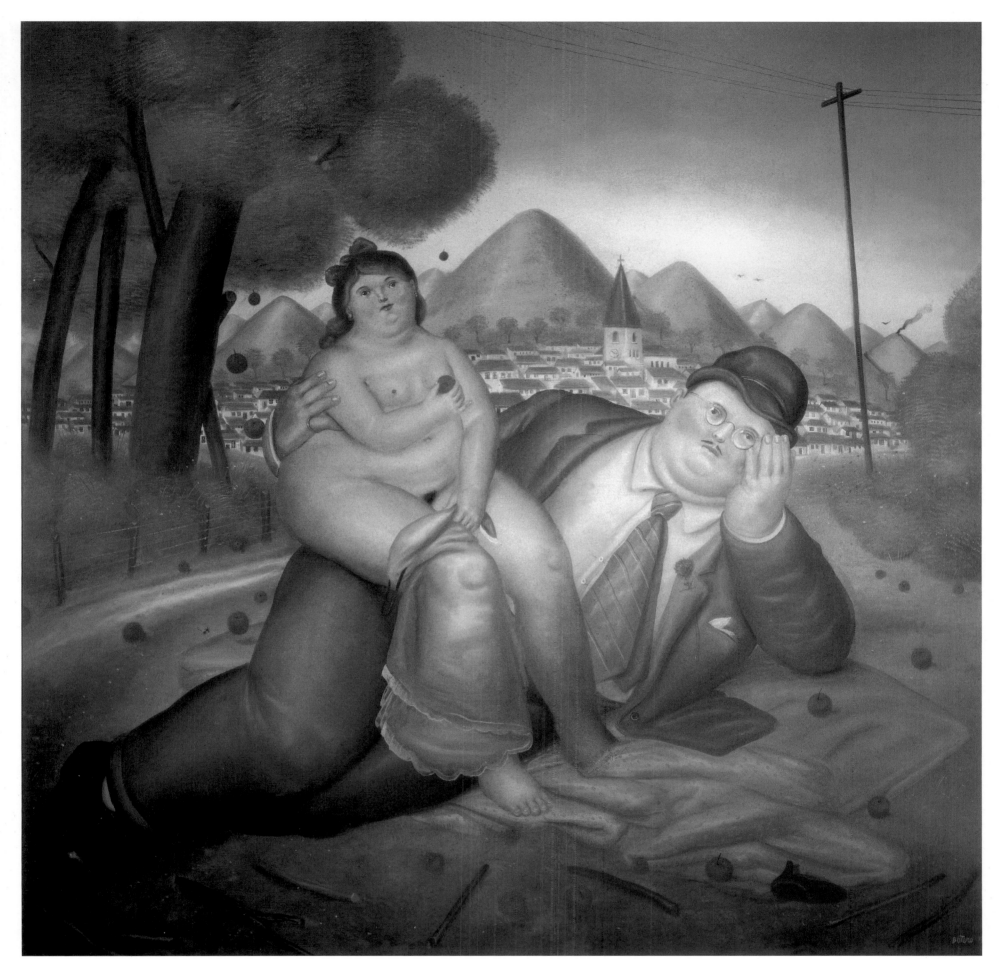

Fernando Botero · Loving Couple

Fernando Botero
Loving Couple, 1973
Liebespaar
Couple d'amoureux
Pareja de amantes
恋人同士

Oil on canvas, 183 x 190 cm
Private collection

Botero calls this picture *Loving Couple*, but is that what it really depicts? There are no clear answers to questions like these such as may be asked by a beholder, Botero's pictures keep their secrets.

Liebespaar nennt Botero dieses Bild, aber handelt es sich wirklich um ein solches? Auf solche Fragen des Betrachters gibt es keine eindeutigen Antworten, Boteros Bilder bewahren ihre Geheimnisse für sich.

Botero donne pour titre à ce tableau *Couple d'amoureux*. Mais s'agit-il là vraiment d'un couple d'amoureux ? A de telles questions de la part du contemplateur, il n'y a pas de réponses bien précises. Les tableaux de Botero gardent leurs secrets pour eux.

Pareja de amantes denomina Botero este lienzo; pero ¿es realmente así? A tales cuestiones que se plantea el observador no hay respuestas; las obras de Botero guardan sus secretos para sí.

ボテロはこの絵を《恋人同士》と名付けているが、これは本当に恋人のカップルを描いたものなのだろうか？鑑賞者のこうした疑問に対する明らかな答えはない。ボテロの絵は内に秘密を抱えているのである。

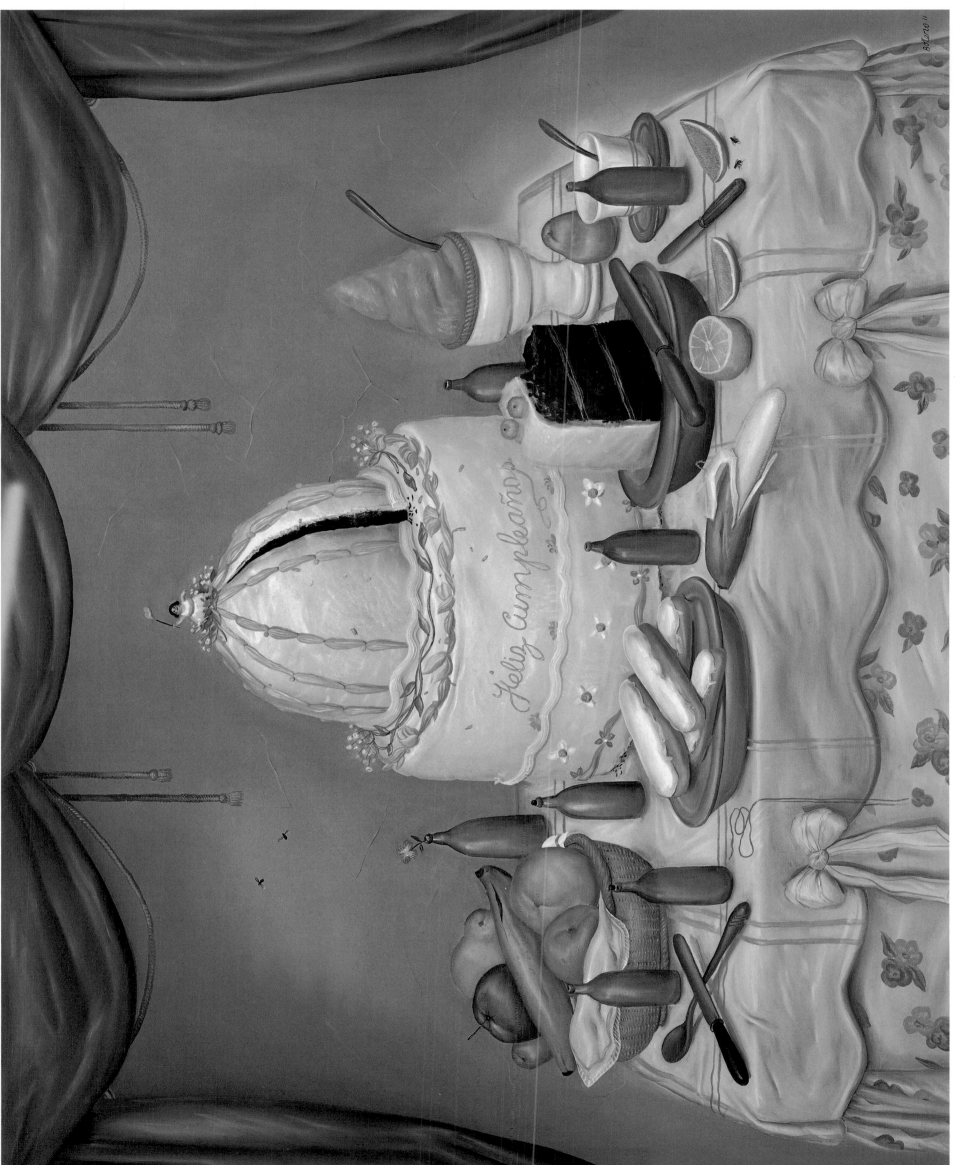

Fernando Botero · Bon Anniversaire

Fernando Botero
Bon Anniversaire, 1971
誕生日おめでとう

Oil on canvas, 155 x 190 cm
Private collection

Even more sensuous than Botero's female nudes are his still lifes – a genre that traditionally has been preferred by painters for the pure pleasure in painting that it provides, and as a virtuoso demonstration of their skill.

Noch sinnlicher als Boteros weibliche Akte sind seine Stillleben – eine Bildgattung, die traditionell von den Malern aus purer Freude an der Malerei und als virtuoser Beweis ihrer Kunstfertigkeit bevorzugt wurde.

Les natures mortes de Botero sont encore plus sensuelles que ses nus. La nature morte a toujours tenu une place de choix dans l'œuvre des peintres qui l'ont pratiquée par pur plaisir et pour montrer leur virtuosité.

Más sensuales que sus desnudos femeninos son las naturalezas muertas de Botero, un género elegido por los pintores como expresión del puro placer de pintar y como prueba de su virtuosismo.

ボテロの描く女性のヌード以上に官能的なものは、彼の静物画である。静物画——、それは伝統的に、画家たちが絵を描く純粋な喜びを感じ、また芸術的技能を証明する手段として、他のジャンルの絵よりも好んだものである。

Fernando Botero · The Rape of Europa

Fernando Botero
The Rape of Europa, 2001
Der Raub der Europa
L'enlèvement d'Europe
El rapto de Europa
エウロペの誘拐

Oil on canvas, 53 x 44 cm
Private collection

In no other motif does Botero's vocabulary of voluminous forms come across more aggressively than in the female nude; no other motif in his world of images stays longer in the memory than these massive figures with their overflowing hips and colossal thighs.

In keinem anderen Bildthema kommt Boteros voluminöses Formenvokabular aggressiver zur Geltung als im weiblichen Akt; kein anderes Motiv seiner Bilderwelt bleibt im Gedächtnis länger haften als jene massigen Gestalten mit ihren überquellenden Hüften und kolossalen Schenkeln.

C'est assurément dans ces peintures de nus féminins que la dilatation des volumes prend une densité agressive ; aucun motif ne reste aussi longtemps inscrit dans la mémoire que ces créatures aux hanches débordantes et aux cuisses énormes.

En ningún otro tema pictórico resalta tan agresivamente el voluminoso vocabulario formal de Botero como en el desnudo femenino; ningún otro de sus motivos se mantiene tan vivo en la memoria como esas figuras ampulosas con sus caderas descomunales y muslos colosales.

ボテロの豊満な形のボキャブラリーは、女性のヌードで最も刺激的な形で真価を発揮している。
ボテロの絵の世界では、はち切れんばかりの腰と巨大な太ももをもつ、こうしたどっしりした姿以上に長く
記憶にとどまるモチーフはほかにない。

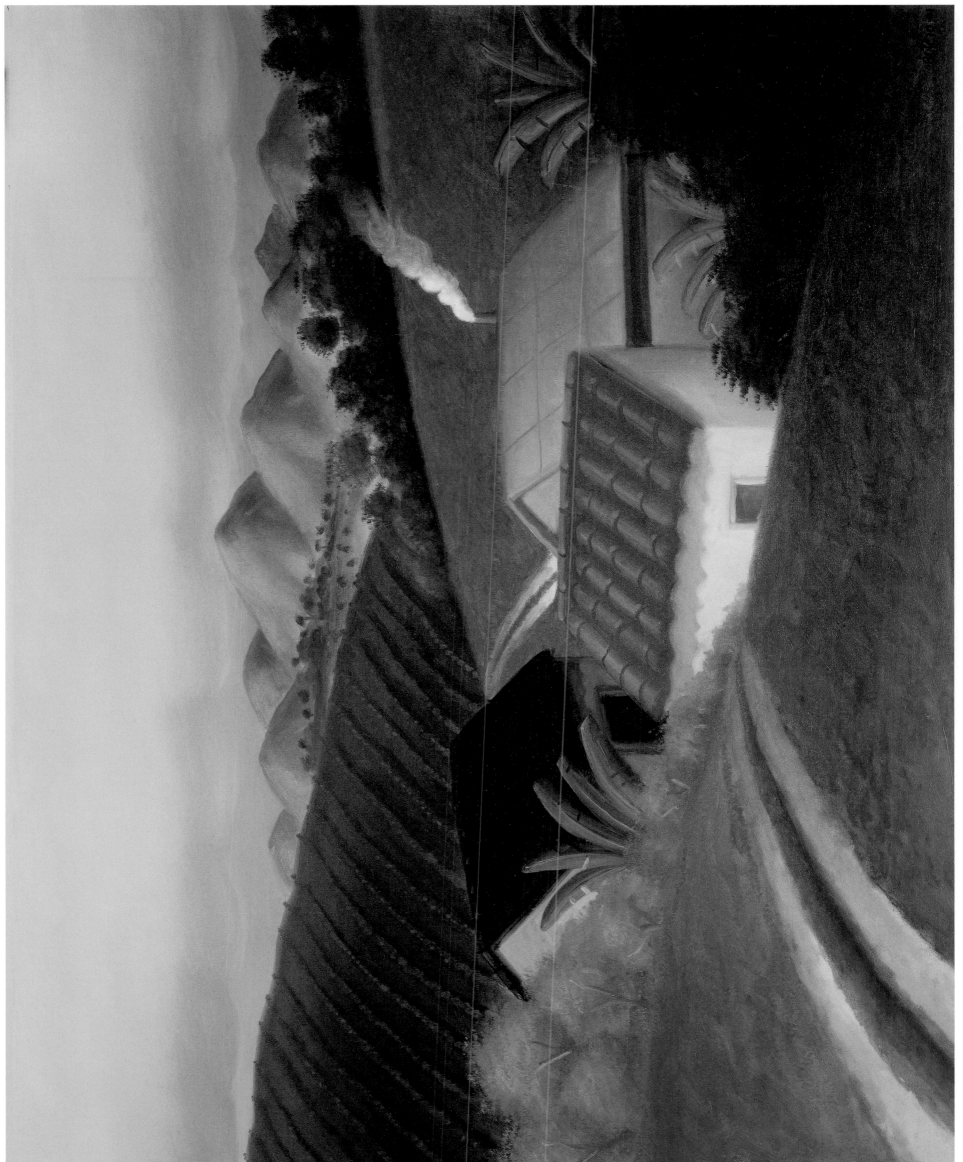

Fernando **Botero** · The Street

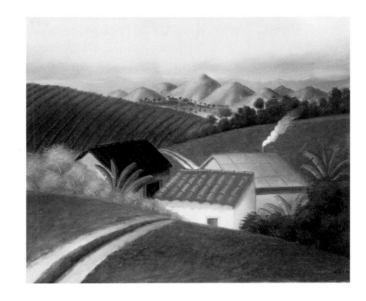

Fernando Botero
The Street, 2001
Die Straße
La rue
La calle
道

Oil on canvas, 77.5 x 94 cm
Private collection

South America is not a place to go looking for formalistic aesthetics. On the contrary, it is characterized by a decidedly communicative view of art, which prefers the message, the symbol, and not least a recognizable picture.

Südamerika ist keine Gegend für formalistische Ästhetik. Sie charakterisiert sich vielmehr durch eine ausgesprochen kommunikative Kunstauffassung, die die Botschaft, das Symbol und auch das erkennbare Bild bevorzugt.

L'Amérique du Sud ne se prête pas à l'esthétique formaliste. Elle a une conception très communicative de l'art, qui privilégie le message, le symbole et l'image reconnaissable.

América del Sur no es una región en la que florezca la estética formal. Por el contrario, se caracteriza por una concepción del arte decididamente comunicativa, que prefiere el mensaje, el símbolo y también la imagen reconocible.

南アメリカは形式的な美を求める場所ではない。この地域はむしろ、メッセージやシンボル、そして認識可能な絵を好む、きわめて伝達性の高い芸術観によって特徴づけられる。

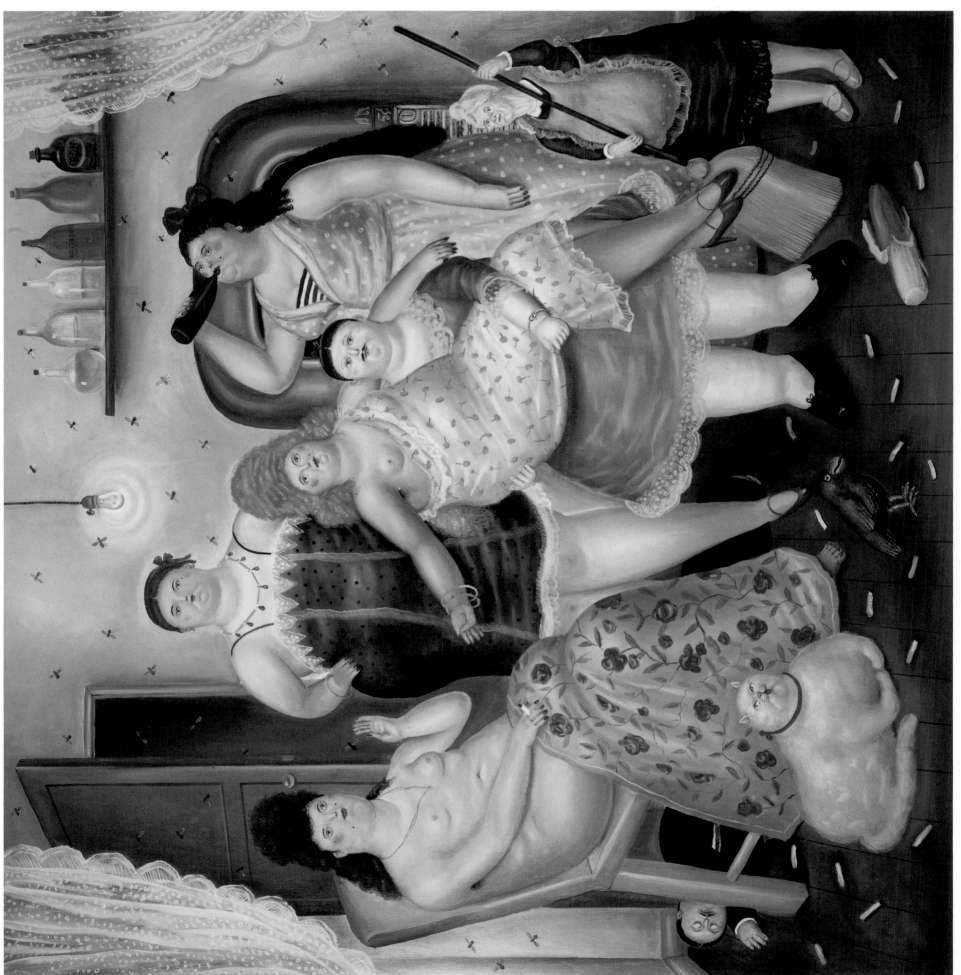

Fernando Botero
The House of Mariduque, 1970
Das Haus von Mariduque
La Maison de Mariduque
La casa de Mariduque
マリドゥケの家

Oil on canvas, 180 x 186 cm
Private collection

"I need total freedom where proportions are concerned. If I need a small form somewhere in a picture, for example, I can reduce the size of a figure."

„Ich brauche totale Freiheit, wenn es um Proportionen geht. Wenn ich etwa eine kleine Form irgendwo in einem Bild brauche, kann ich eine Figur verkleinern.“

« J'ai besoin d'une grande liberté quand il s'agit des proportions. Si j'ai besoin d'une petite forme quelque part dans un tableau, je peux réduire une silhouette. »

«Necesito total libertad cuando se trata de proporciones; por ejemplo, si preciso una pequeña forma en algún lugar del cuadro, puedo reducir una figura».

「プロポーションに関して、私は完全な自由が必要だ。絵のどこかに小さな形が要る場合、私はサイズを縮小できる」

FERNANDO BOTERO

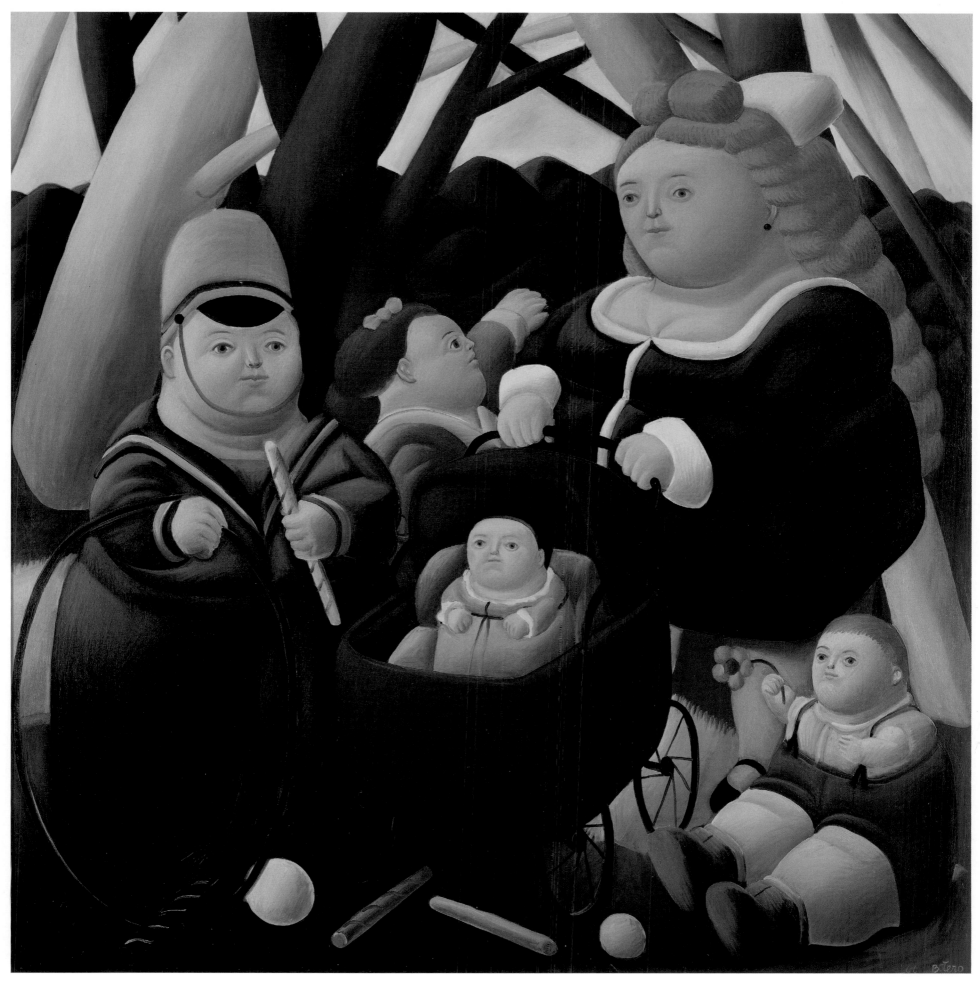

Fernando Botero · The Rich Children

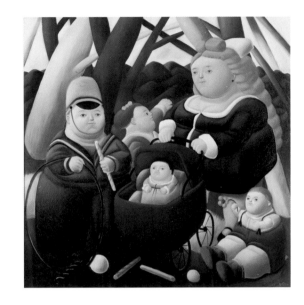

Fernando Botero
The Rich Children, 1968
Die reichen Kinder
Les enfants riches
Niños ricos
裕福な子供たち

Oil on canvas, 98.1 x 195.6 cm
Private collection

"For me, a personality like Rivera was always of the highest importance. He showed us young Central American painters the possibility of creating an art that need not be colonized by Europe."

„Für mich war eine Persönlichkeit wie Rivera von höchster Bedeutung. Er zeigte uns jungen mittelamerikanischen Malern die Möglichkeit, eine Kunst zu schaffen, die nicht durch Europa kolonisiert sein braucht.“

« Une personnalité comme celle de Rivera était pour moi capitale. Il nous a montré, à nous, jeunes peintres d'Amérique centrale, la possibilité de créer un art, libre de toute colonisation européenne. »

«Para mí, tuvo una gran importancia una personalidad como Rivera. A los jóvenes pintores centro-americanos nos enseñaba la posibilidad de crear un arte no colonizado por Europa».

「私にとって、リヴェラのような人物は最も重要だった。彼は私たち中央アメリカの若い画家に、ヨーロッパによって植民地化される必要のない芸術を創作する可能性を示してくれた」

FERNANDO BOTERO

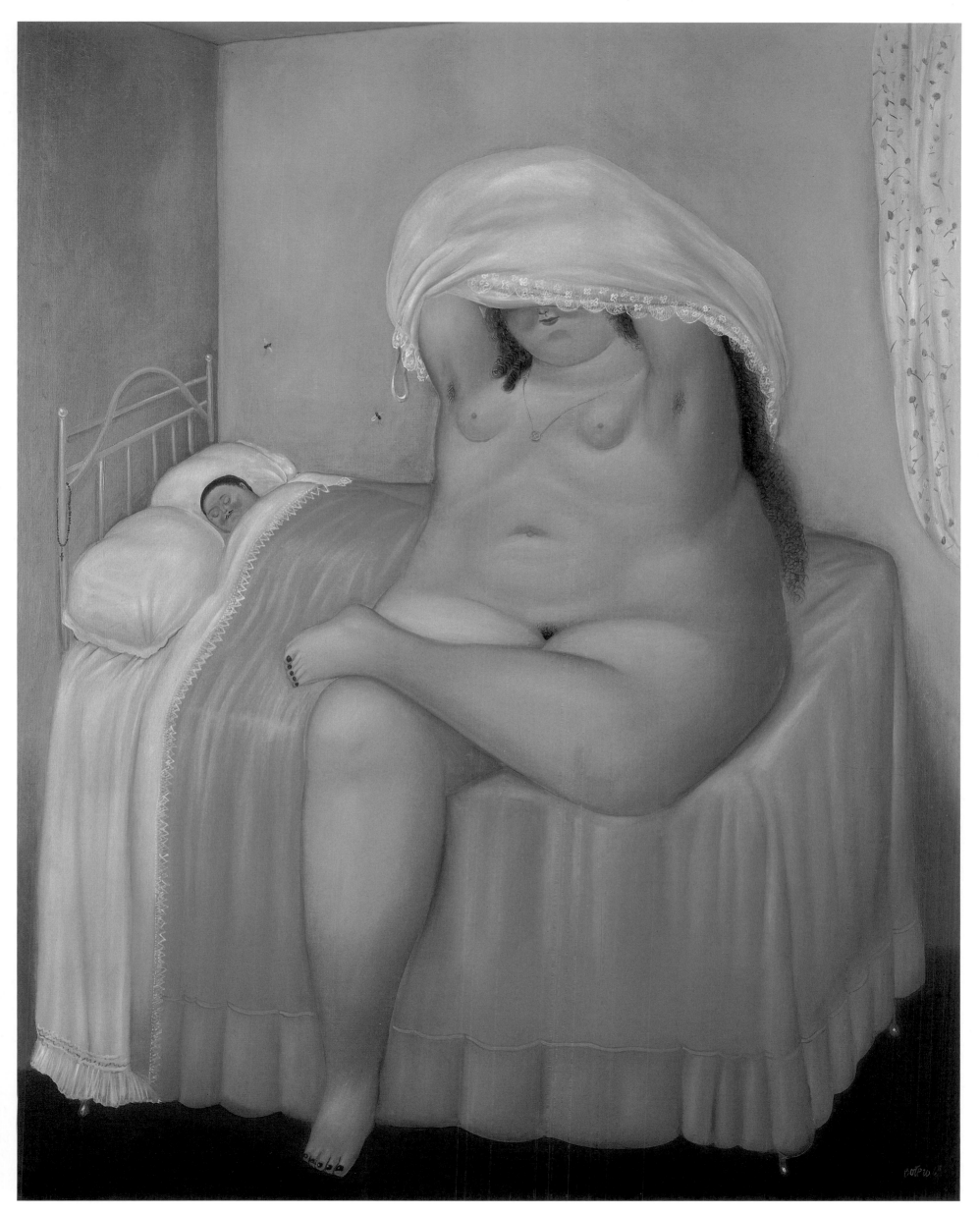

Fernando Botero · The Lovers

Fernando Botero
The Lovers, 1969
Die Liebenden
Les amants
Los amantes
恋人たち

Oil on canvas, 190 x 155 cm
Galerie Brusberg, Berlin

"A still life is not a botanical engraving. The issue is not the fruit, but the picture.
The same goes for men and women."

„Ein Stillleben ist kein botanischer Stich. Die Frage ist nicht die Frucht, sondern das Bild.
Das Gleiche gilt für Männer und Frauen."

« Une nature morte n'est pas une gravure botanique. Ce n'est pas le fruit en lui-même qui importe,
c'est la toile. C'est pareil pour les hommes et les femmes. »

«Una naturaleza muerta no es un grabado botánico. La cuestión no es la fruta, sino el cuadro.
Y lo mismo puede decirse de los hombres y las mujeres».

「静物画は植物学的な版画ではない。問題は果物ではなく、絵である。同じことは男女にも当てはまる」

FERNANDO BOTERO

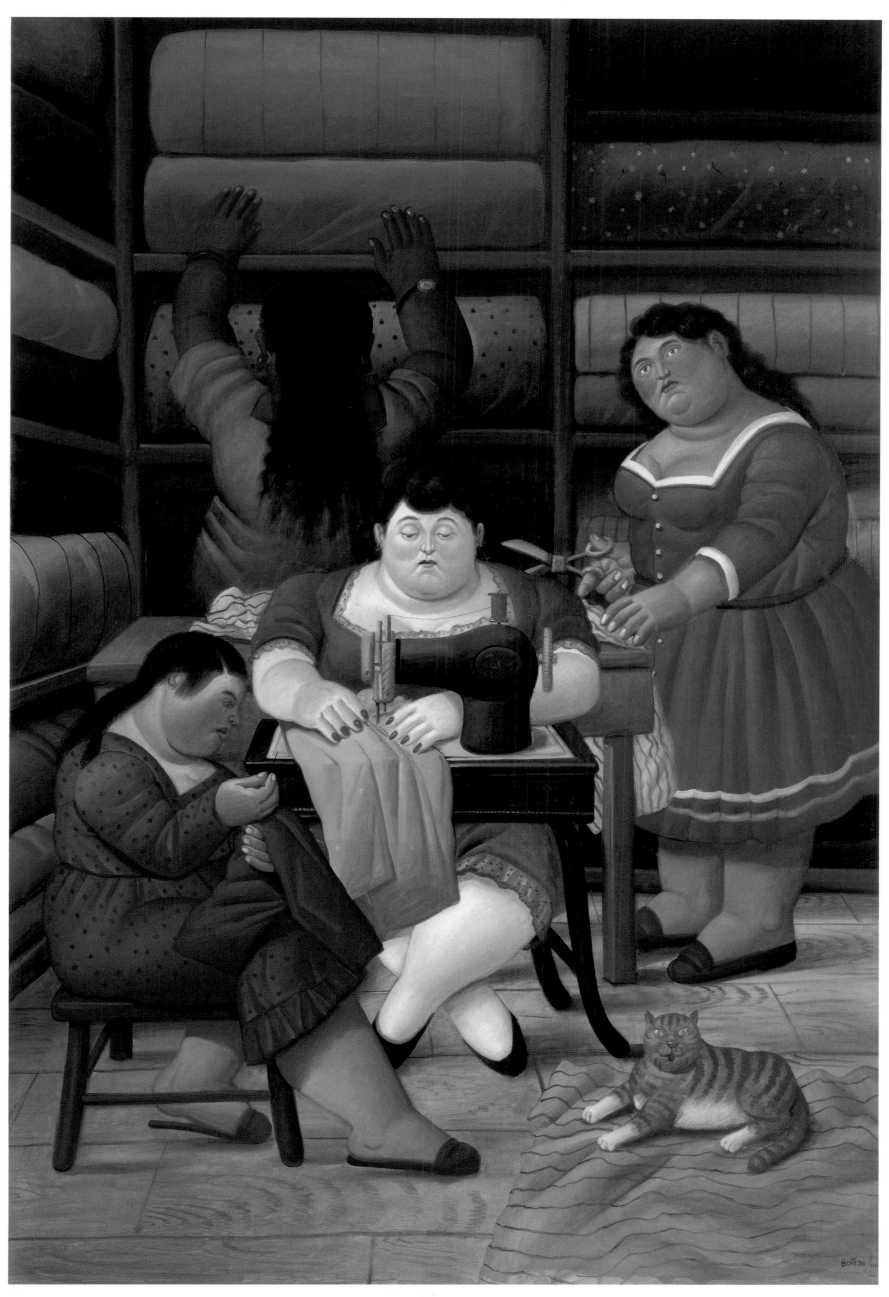

Fernando Botero · The Seamstresses

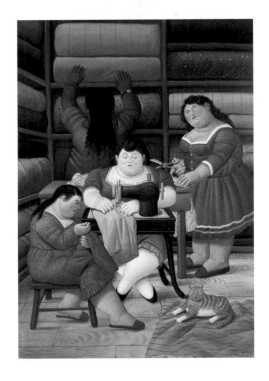

Fernando Botero
The Seamstresses, 2000
Die Näherinnen
Les couturières
Las costureras
お針子

Oil on canvas, 205 x 143 cm
Private collection

"The picture achieves perfection only when the color question has been solved. You think about the composition, but in reality it is the color that determines the picture. When every element has found its place, there is peace."

„Das Bild findet erst dann seine Vollendung, wenn die Farbe gelöst ist. Man denkt an die Komposition, aber in Wirklichkeit ist es die Farbe, die das Bild bestimmt. Wenn jedes Element seinen Platz findet, gibt es Frieden."

« Le tableau n'est achevé que lorsque la couleur se dissout. On pense que c'est la composition qui est la maîtresse du tableau, mais en réalité c'est la couleur. Le calme s'installe à partir du moment où chaque élément a trouvé sa place. »

«El cuadro solo encuentra su perfección cuando se ha aplicado el color. Se suele decir que la composición define el cuadro, pero en realidad se debe al color. Cuando cada elemento ha encontrado su lugar, hay paz».

「色が絵に溶け込んだところで、絵はようやく完成する。人は構図のことを考えるが、絵を決めるものは、実は色なのである。それぞれの要素が自らの場所を見出した時、平和が訪れるのだ」

FERNANDO BOTERO

© 2006 TASCHEN GmbH
Hohenzollernring 53, D–50672 Köln
www.taschen.com
© 2006 Fernando Botero